E. Munch

# THE LIFE AND WORKS OF

*E. Munch*

# MUNCH

## Amanda O'Neill

A Compilation of Works from the
BRIDGEMAN ART LIBRARY

PARRAGON

**Munch**

This edition first published in 1996 by
Parragon Book Service Ltd
Units 13-17 Avonbridge Industrial Estate
Atlantic Road
Avonmouth
Bristol BS11 9QD

ISBN 0 75251 690 6

Printed in Italy

**Editors**: Barbara Horn, Alexa Stace, Alison Stace, Tucker Slingsby Ltd and Jennifer Warner.
**Designers**: Robert Mathias and Helen Mathias
**Picture Research**: Kathy Lockley

The publishers would like to thank Joanna Hartley at the Bridgeman Art Library for her invaluable help.

# EDVARD MUNCH 1863-1944

E. Munch

**M**ORE THAN ANY OTHER MODERN ARTIST, the Norwegian master Edvard Munch is identified in the popular mind with a single painting: *The Scream* (page 23). The product of his own spiritual torment, it has become an icon of modern *Angst*. Perhaps only one other painting, Leonardo's *Mona Lisa*, is so deeply embedded in the general consciousness. (Munch compared Leonardo's dissection of corpses with his own dissection of souls.) Like *Mona Lisa*, *The Scream* has suffered theft and recovery (making international headlines in 1994) and has been so often dragged into the service of cartoonists and advertisers that its misuse has become a cliché. A host of beleaguered politicians have been caricatured in the open-mouthed, ear-clamped pose at times of crisis; in an advertisement for mobile telephones, *The Scream* becomes The Smile; it is even possible to purchase life-size inflatable Screams in novelty shops! It is a measure of the image's true worth that such treatment cannot trivialize it.

'Illness, madness and death were the black angels that kept watch over my cradle,' said Munch. The trauma caused during his childhood in Oslo (then called Christiana) by the deaths from tuberculosis of his mother and sister were exacerbated by the religious mania of his father. In his late teens, he fled from his oppressive home to Oslo's Bohemia, abandoning engineering studies for the studio of Christian Krohg (1852-1925), the leading Norwegian Naturalist painter. Munch exhibited regularly in Oslo from 1883, extending the boundaries of the then somewhat comfortable Scandinavian Realism far enough to cause a scandal with *The Sick Child* in 1886. By this time he had begun regular visits to France and Germany, where his mature style developed under the major influences of the swirling lines of Van Gogh, the flat, simplified patterning of Gauguin and his fellow-Symbolists, and the vivid tonalities of the Neo-Impressionists.

In 1891, shortly after announcing his determination to paint 'human beings who breathe and feel and love and suffer', Munch began *The Frieze of Life; a poem of life, love and death*, a sequence of paintings expressing, by means of distorted line and harsh, dissonant colours, the loneliness, despair and physical and mental agony that to him formed human life. *The Scream* was one of this series, and was among the many images that he was later to reproduce in the etchings, lithographs and woodcuts that form a most important part of his work: he may be said to have almost revolutionized the art of woodcut. He now lived mainly in Germany, where his fame was assured when public protest at his shocking works (in the true sense; his fellow Scandinavians Ibsen and Strindberg caused similar scandal in the theatre) led to the speedy closure of his first Berlin exhibition in 1892.

This rejection triggered a reaction by artists who supported Munch and 'Modernism'. Sezessionen, groups revolting against the art establishment, were formed in Munich, Vienna and Berlin. The Berlin Sezession triumphantly exhibited 22 paintings from *The Frieze of Life* in 1902. The Sezessionen and their offspring, like *Die Brücke* ('The Bridge'), founded in Dresden in 1905, and *Der Blaue Reiter* ('The Blue Rider'), founded in Munich in 1911, were the source of Expressionism, the dominant movement in painting and a major force in literature, drama and cinema, architecture and music into the 1930s. Acknowledging Van Gogh, Gauguin and Munch as its immediate forebears, Expressionism aimed primarily to express the artists' emotional experience. Expressionist works may, like Munch's pictures, be representational, but achieve their effect by distortion of form (either by simplification or exaggeration) and the use of striking and often incongruous colour. Like Munch himself, the Expressionists were paid the compliment of being denounced as 'degenerate' by the Nazis.

In 1908, increasingly heavy drinking and a destructive love affair combined with Munch's ever-present melancholia to drive him into a mental home. Although he himself stated that 'I would not cast off my illness, for there is much in my art that I owe to it', he emerged a significantly changed

man. The rest of his long life was spent as a semi-recluse in his native land. The near-demonic intensity of his earlier works is generally absent from his later paintings, which display a  livelier technique and a brighter palette. Nature is allowed to stand for itself instead of symbolizing the agony of humankind: he no longer 'painted the clouds as actual blood', as he had described those in *The Scream*. His large oils on themes from history, science and nature, executed for the University Hall of Oslo in 1910-15, stress positive qualities.

Yet the demons still lurked, and in his old age the artist produced one of his most striking images of the existential crisis of modern life. The self-portrait (the last of many such he painted) *Between the Clock and the Bed* (1940-42) shows the aged Munch in a sunlit room. The brushstrokes are bold; the colours bright; the man stands erect and apparently unafraid. But he stands between a grandfather clock, which ticks off the little time he has left, and the bed on which he is soon to die. To the end, Munch was, in Housman's words, 'a stranger and afraid, in a world I never made'. Like that tormented poet, and like Van Gogh, whom he so much resembled in his tortured being, he transcended his fear and alienation so as to give his fellow humans a new way of seeing that world, helping them find the strength to bear what they cannot change.

▷ **Self-portrait** 1882
© DACS 1996

Oil on canvas

THE YOUNG MAN whose challenging yet uncertain stare meets ours had emerged from his troubled childhood and his doubts about the career he should take. Still in his teens when he painted this self-portrait, Munch was already committed to the life of an artist. With six other students, he had rented his first studio in Christiana (now Oslo) and become a pupil of Christian Krohg, a prominent figure in the Christiana Bohemian circle. Krohg, was inspired by the Realism movement. He scandalized Oslo with his paintings of low life, particularly prostitutes, and his novel *Albertine* (1886), recounting a prostitute's career. He was the first to recognize Munch's ability, and gave the young painter much-needed encouragement. Munch painted a great many self-portraits over the years. In general, these intense, brooding studies are concerned to portray a mood or emotion rather than a face or character. When, as here, he poses formally, a certain stiffness and wariness persist which he avoids in his portraits of others.

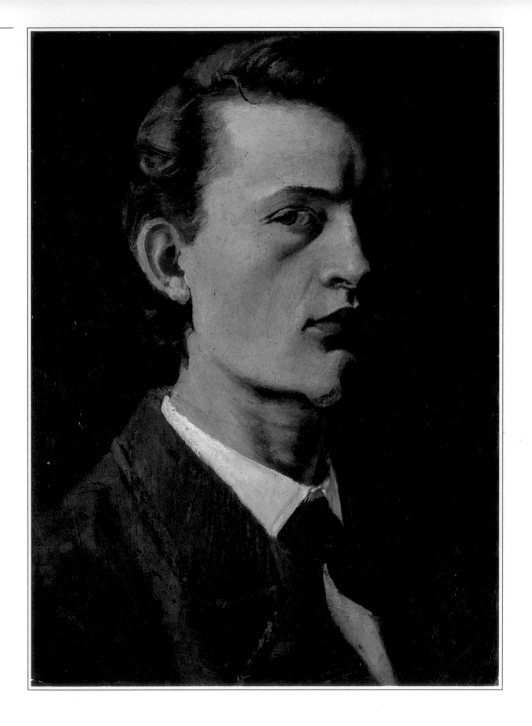

▷ **Morning** 1884
© DACS 1996

Oil on canvas

VICTORIAN GENRE PAINTING meets social realism! The subject, an interior with a woman gazing out towards a window, was a favourite with 19th century romantic painters. Scores of paintings depicted fine ladies in a gilded cage yearning towards a forbidden, romantic freedom beyond the window. Munch has reversed the theme in making his heroine a working-class girl, caught in quite a different cage. More than that, he has turned the whole convention on its head by his emphasis on the morning light that floods her room. He has not painted the symbolic window itself, but concentrated on its effects. What could have been a low-life study of poverty becomes a celebration of light. The morning light fills the bare room with a soft radiance. It dwells lovingly on the warm glow of the girl's skin, the rich auburn tints in her hair. In a moment of reverie before her working day begins, the girl has achieved her own fragile and finite escape from her surroundings. Munch's impressionistic treatment of his subject was regarded as 'slapdash' by critics at the Fall Exhibition in 1884, yet it is quite the reverse.

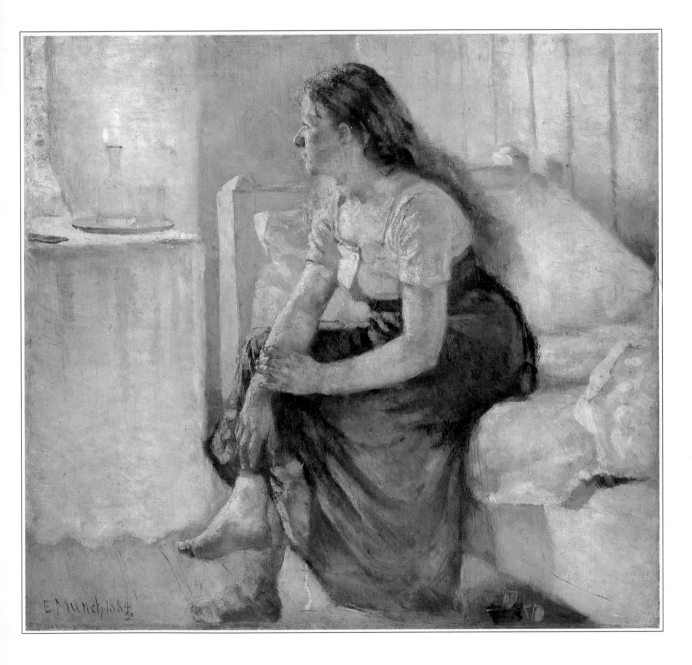

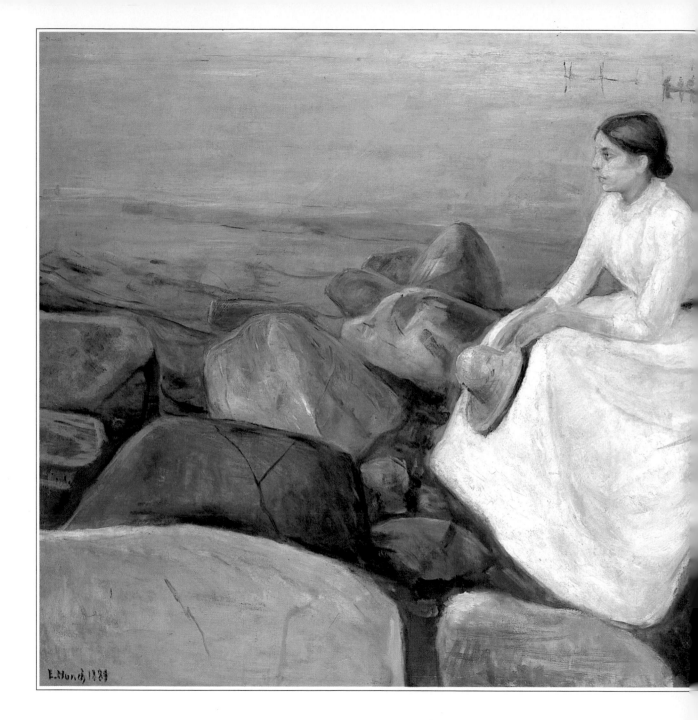

◁ **Inger on the Beach** 1889
© DACS 1996

Oil on canvas

MUNCH USES A SIMILAR POSE to *Girl on the Edge of the Bed* (page 10) for his model in this picture, seated in lonely reverie, her face in profile. Here too, he is concerned to capture a particular quality of light. This time, it is an exterior scene, and the blue clarity of a evening sunlight on the sea. As before, he has intensified the impact of the light by leaving its source out of his painting: unusually for a seascape, the horizon and sky are cropped. The comforting solidity and rounded shapes of the boulders in the foreground speak of the enduring qualities of the natural world. In this peaceful scene, the human figure is completely integrated with her surroundings. Her white dress partakes of the luminous quality of the sea, while its statuesque drapery adopts the curves of the boulders where she sits. The woman is Munch's youngest sister Inger (1868-1952). Inger was a rare figure of security in Munch's troubled life. He painted her portrait several times, and she also appears as a model in a number of paintings.

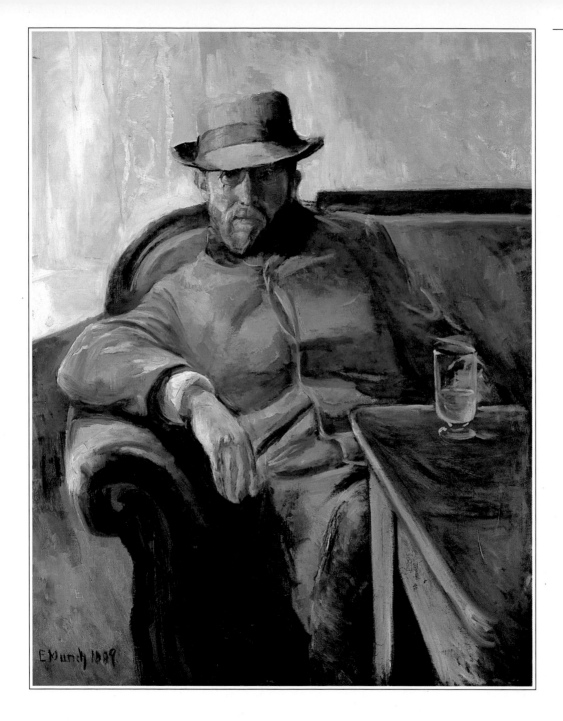

◁ **Portrait of Hans Jaeger**  1889
© DACS 1996

Oil on canvas   109 x 84cm

HANS JAEGER was a leading spokesman for the Christiana Bohemian group. An intellectual and anarchist, he succeeded all too well in his desire to shock the bourgeoisie when he brought out an autobiographical novel From the *Christiana Bohemians*. The book was condemned as 'pornographic' and confiscated; its author was sentenced to two months in prison. That he also succeeded in his desire to encourage fellow rebels on the road to intellectual and artistic freedom, Munch acknowledged when, in 1926, he noted, '. . . my ideas developed under the influence of the Bohemians or rather of Hans Jaeger.' In Munch's portrait of his friend and mentor, Jaeger leans back and eyes the viewer challengingly, as if ready for debate. His heavy coat almost takes on a life of its own. On the one hand, by emphasizing his bulk, it reinforces our sense of his compelling presence. On the other hand, despite the man's relaxed posture, the coat is tightly buttoned up to the neck, giving the lie to his apparent ease. By suggesting inner tensions it hints at a more complex character than the confident gaze implies.

**Music on Karl Johann Street**  1889
© DACS 1996

Oil on canvas   102 x 141.5cm

▷ *Overleaf pages 16-17*

'WHEN A BAND came down Karl Johann Street on a clear sunny day in spring,' Munch recorded, 'my mind was filled with festivity, spring, light; music became quivering joy, music painted the colours. I painted the colours I saw.' Oslo's fashionable main street is depicted in light but neutral colours, among which the puddles in the road sparkle brilliantly. The crowd masses together to become a single, amorphous being, though not yet a threatening presence as it will become in later paintings. Those few figures who have broken away from the mass in the middle ground are delightfully captured. On the left, two little girls find a puddle more absorbing than the band. Perhaps they have escaped for a moment from the stern gentleman with his cane and top hat, and the woman standing meekly near him. On the right, an elderly couple in black move on their dignified, solitary way. The foreground figures are brutally cropped, giving the picture depth and tension and driving our eyes on beyond them (and beyond the poppy-like bloom of the red umbrella) to the heart of the picture.

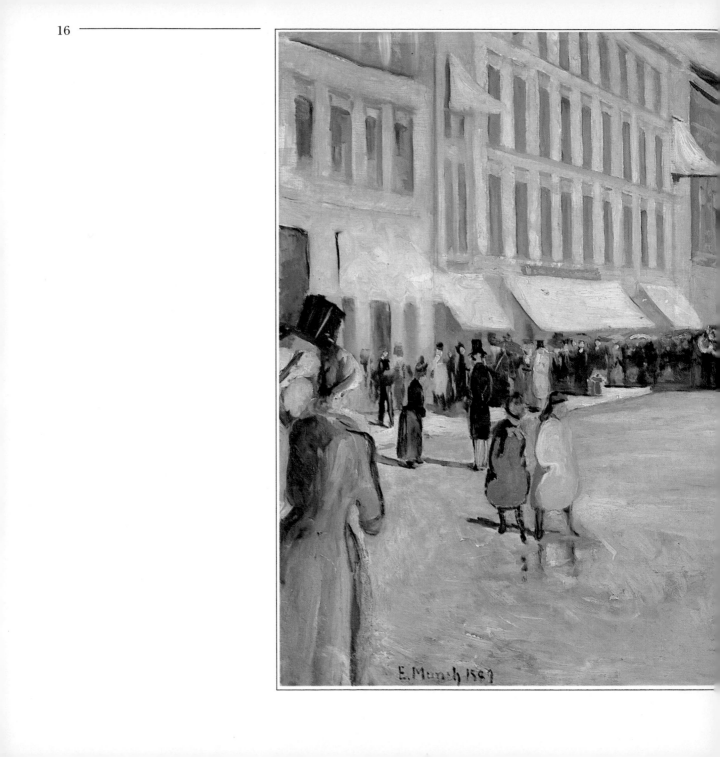

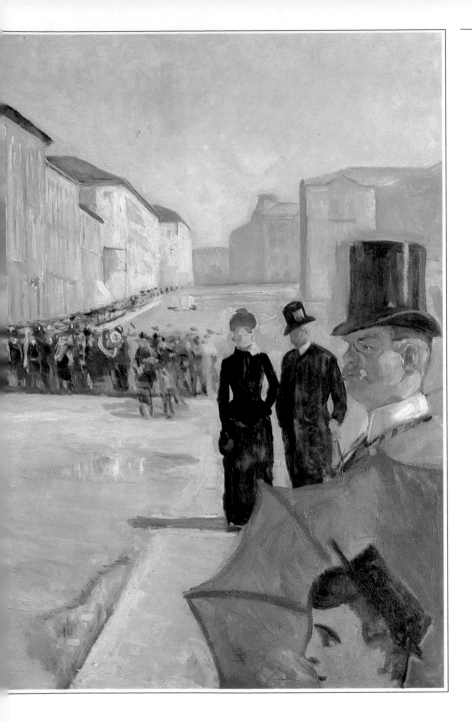

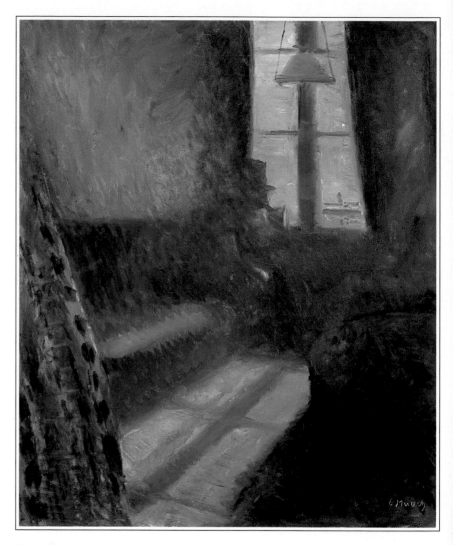

▷ **Night in Saint-Cloud** 1890
© DACS 1996

Oil on canvas 64.5 x 54cm

IN 1889, THE AWARD of a
scholarship enabled Munch
to move to Paris, city of artists.
Here he was exposed to new
influences including the
Symbolist movement, and
experimented with different
techniques. At the same time
his confidence in his own
vision grew, and he twice
abandoned art school to work
on his own. During this period
he suffered from ill health,
depression and the death, in
Norway, of his father. For part
of his stay in Paris he lived
in the residential suburb of
Saint-Cloud, where he painted
this moonlit interior – the last
painting of his 'Naturalist'
period, before he became
committed to Expressionism.
The night has transmuted
the room's colours to subtle,
melancholy shades. Beyond
the window, the bright lights
of a river steamer remind us
that life goes on outside. But
the dark figure seated within
(identified as Munch's close
friend, the Danish Symbolist
poet Emanuel Goldstein) is
embraced in the room's
tranquil atmosphere. Some
critics see the shape of a cross
in the window-frame's shadow
on the floor, and infer a
reference to Munch's grief
at his father's death.

▷ **Despair** 1891
© DACS 1996

Gouache and charcoal
37 x 42cm

DURING HIS STUDIES in Paris,
Munch's views on the role of
art began to crystallize. More
and more he felt it important
to paint emotions, moods,
universal truths about the
human condition, rather than
mere exteriors. In his diary,
he noted: 'No more interiors
should be painted, no people
reading, no women knitting.'
His subjects, he resolved,
'should be living human
beings, who breathe and feel,
suffer and love.' In this study,
a faceless figure leans on the
edge of the pier, apparently
lost in thought. Eyeless, he is
unaware of the swirling
landscape before him, the couple
enjoying their promenade
beyond him, or the shocking,
blood-coloured sunset above.
This vision of despair was to
grow in Munch's inner eye
until it blossomed out into
his best-known painting *The
Scream* (page 23). By that stage
'desperation' has become
full-blown terror, and the
savage sunset becomes
integrated with the landscape
and the figure itself.

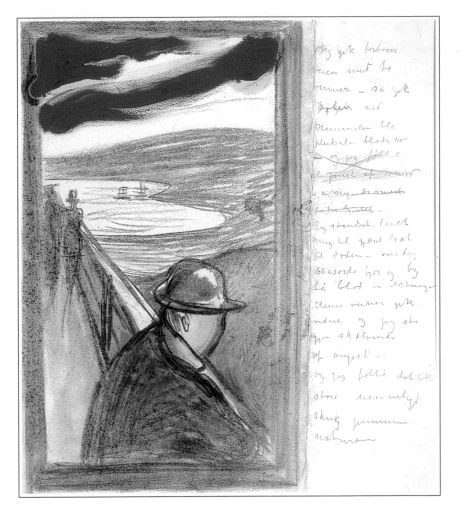

▷ **Evening in Karl Johann Street, Oslo** 1892

Oil on canvas  84.5 x 121cm

OSLO'S MAIN STREET again serves as the setting for a mood painting as it is transformed into a nightmare vision of human alienation. The simplified lines of houses and human figures and the flat areas of colour are reminiscent of Gauguin, but the emotional intensity of the scene is Munch's own. The evening flow of homegoing workers heading down the street becomes a grim stream of blank-faced, dehumanized creatures. Pressed together as tightly as sardines, they are nonetheless separated from each other, their empty eyes avoiding contact with each other. With legs cropped, they give the impression of moving as mechanistically and relentlessly as objects on a conveyor belt. Apart from them, a solitary, dark figure – Munch himself – moves in the opposite direction. His stance is hesitant. He is not stepping out confidently in splendid isolation, but facing the terrors of a long, lonely stretch of road. In this vision of the human dilemma, the only alternative to spiritual death by absorption into the mindless crowd is absolute loneliness.

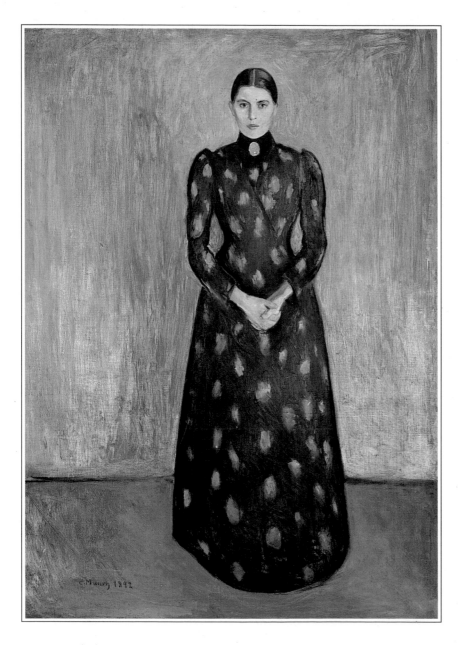

◁ **Portrait of Inger Munch**
1892
© DACS 1996

Oil on canvas  172.5 x 122.5cm

THE INFLUENCE OF WHISTLER
may be detected in the muted,
translucent colours of this
portrait, originally titled *Black
and Violet.* Inger stands, slightly
off-centre, against an empty yet
subtly shadowed background.
She is formally posed in an
attitude suggesting calm
authority, her hands clasped
before her, her steady gaze
looking outwards beyond the
painting. Her 'black and violet'
dress is stylized into a deliberate
flatness with no suggestion of
realistic mass or form. Munch
must have been satisfied that
this serene pose captured an
essential quality in his sister,
for he was to use it again (and
the same or a very similar dress)
a year later in his harrowing
*Death in the Sickroom.* In that
portrayal of his shattered family
at his younger sister Sophie's
deathbed, Inger stands out as
the only figure who remains
erect and controlled, while the
others wilt under their grief.
Here, as in *Inger on the Beach*
(page 13), Munch captures
the calm strength that he
respected in his sister.

▷ **The Scream**  1893
© DACS 1996

Tempera and oil pastel
on cardboard
91 x 73.5cm

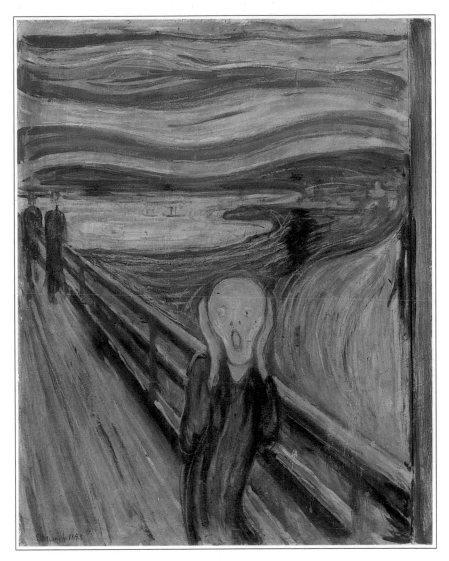

*The Scream* has become an icon of our times, an image familiar to many who have never even heard of Munch himself:  The whole landscape expresses a human emotion, in this case pure terror. The screaming figure is stripped to its elements: a skull-like face, a twisted, agonized posture. Perspective is exaggerated, so that the slashing lines of the pier cut sharply across the vista, and the landscape swirls madly into the sea and the sky. The sunset colours form waves of pain across the picture. The painting's power lies in the fact that Munch is not creating an artificial allegory but conveying his own sense of a reality. The genesis of this tormented vision was a real sunset. 'One evening I was walking along a path, the city was on one side and the fjord below. I felt tired and ill. I stopped and looked out over the fjord – the sun was setting, and the clouds turning blood-red. I sensed a scream passing through nature; it seemed to me that I heard the scream. I painted this picture, painted the clouds as actual

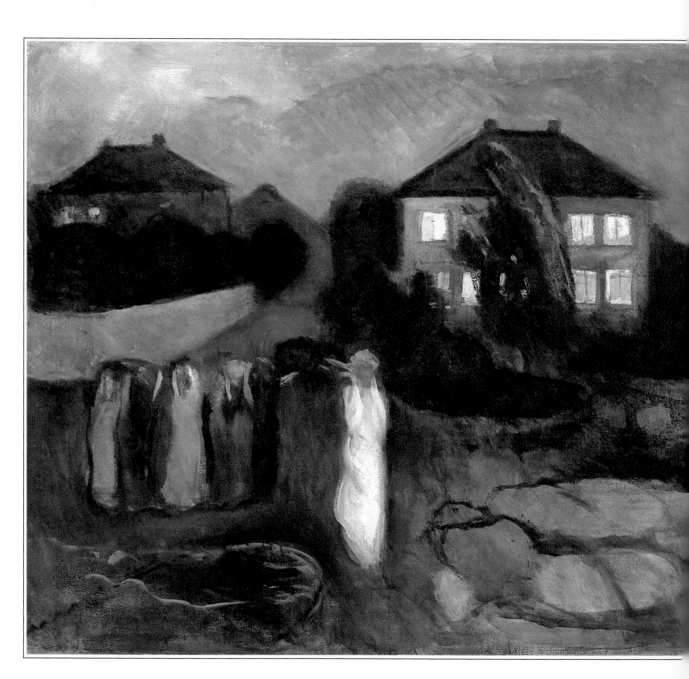

◁ **The Storm**  1893
© DACS 1996

Oil on canvas  36 ⅛ x 51 ½" (91.8 x 130.8cm)

MUNCH SPENT MANY SUMMERS painting at the seaside resort of Åsgårdstrand, some 50 miles from Oslo. Usually in his paintings the resort represents the peace he found so hard to achieve, but here we see the shore wracked by a violent storm. The theme is at once dramatic and cryptic. A shadowy group of women have left the security of the brightly lit house to come out into the storm. Their hands are pressed to their heads, like those of the figure in *The Scream*, in apparent fear. They form a dim, impersonal, supporting chorus behind the woman in virginal or bridal white who walks on into the darkness and towards the sea. Clearly the storm mirrors an emotional turmoil among the human figures, but what those emotions are remains ambiguous. It seems likely that, as so often, Munch is concerned with the terrors of sexual desire and relationships. If the woman's white dress is a bridal gown, the figure may represent the fearful bride leaving the safety of virginity to embark on the stormy path of adult sexuality. The supportive figures behind her can go with her only so far: she must tread the rest of this frightening path alone.

▷ **The Women** 1894
© DACS 1996

Oil on canvas

MUNCH'S MISTRUST of women appears in this portrayal of the traditional female trinity of virgin, temptress and crone. On one side, painted in flat, stylized Art Nouveau curves, the adolescent girl in her white dress of purity stands on the shore. On the other, three figures, more realistically painted, occupy a frightening dark forest. First, the sexually mature woman flaunts her nude body with brazen pose and challenging smile. Next, half-hidden in darkness, comes the older woman – not the hideous crone of tradition but a sad, pale and strangely sinister temptress in widow's weeds. Finally, Munch includes the figure of their prey, a wilting, hangdog man with pale face and downcast eyes. He shares the darkness under the trees with the black widow. This picture suffered a narrow escape before being exhibited in Paris. Trying to dodge the landlord whom he owed rent, Munch threw his paintings out of his window to friends waiting below. It was torn during its adventurous exit, but, a friend recorded, 'we repaired it on the way' and it took its place in the exhibition.

▷ **Ashes** 1894
© DACS 1996

Oil on canvas 120.5 x 141cm

IN A SENSE, this is an old-fashioned, simple genre painting. The picture tells a story, its theme made clear by the title - after the act, two lovers find their passion burned out, turned to ashes. The theme is a favourite of Munch's: the loneliness of humanity, the failure of human relationships, the attempt to draw closer to others only making things worse. The act of union has only driven the lovers apart. There are numerous references to Munch's personal vocabulary of terror. Beyond the rumpled bed lies the same dark forest of fears which appears in *The Women* (page 26). Here, the roots of the tree on the left flow down, partially enclosing the couple: the forest sucks life from the human figures. The man slumped despairingly in the foreground recalls the male figure of that painting, taking his hangdog pose a stage further. Unlike him the woman is still upright, dominating the defeated man (and still entangling him in her hair). But her expression is distraught, and her arms raised in the agonized position Munch used in The Scream and in *The Storm* – a parody of the temptress's triumphant pose in *The Women*.

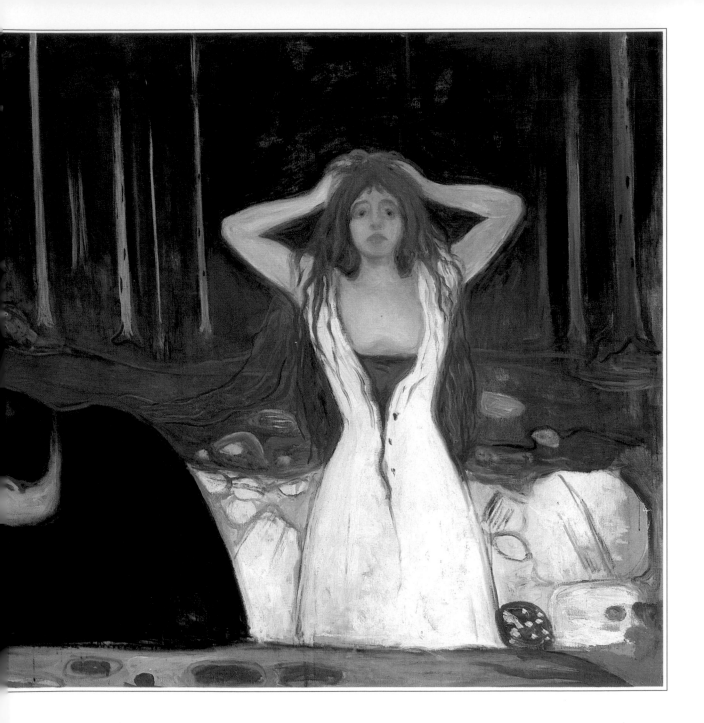

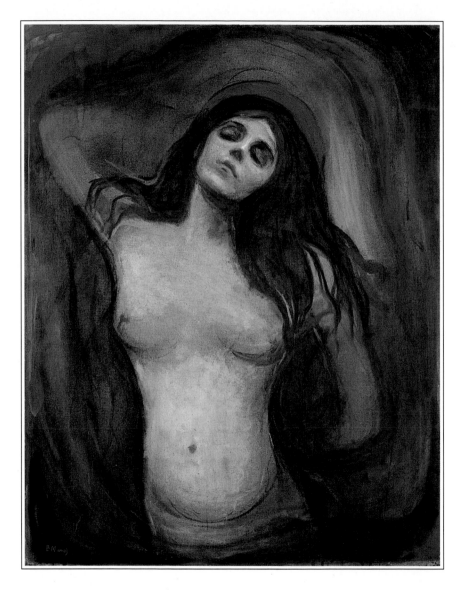

◁ **Madonna** 1894-5
© DACS 1996

Oil on canvas 90.5 x 70.5cm

BETWEEN 1889 AND 1909
Munch produced a group of
paintings called *The Frieze of
Life*, which he envisaged as 'a
poem of life, love and death'.
There is some confusion over
how many of his paintings
belong in this series, but they
certainly include *Madonna*,
along with *Vampire* (page 34),
*Melancholy* (page 44), *The
Dance of Life* (page 48), and his
most famous work, *The Scream*
(page 23). *Madonna* is one of
Munch's most cryptic works.
Originally entitled *Loving
Woman*, it is a strangely unerotic
portrayal of female sexuality.
The woman's ecstasy is a
solitary, impersonal thing,
while her body floats in its
own limbo. Different critics
have seen in her remote
half-smile a glorious ecstasy or
a sinister sterility; Munch
himself considered it 'a
corpse's smile'. Sexual love,
and the cycle of new life, is for
him irrevocably linked to
death: the moment of
conception is 'the chain
binding the thousand dead
generations to the thousand
generations to come'.

▷ **Madonna** 1895-1902
© DACS 1996

Lithograph 60.5 x 44.2cm

As WITH ANY IMAGE which
seemed important to him,
Munch produced many
versions of his *Madonna*,
including lithographs and
woodcuts. By re-working a
theme over and over again,
he hoped to crystallize his
vision into its most powerful
form. This woodcut version
makes the association of
orgasm and procreation more
explicit by incorporating the
image of a foetus in the corner,
and a frame of spermatazoa.
The skull-like face of the
foetus reminds us that death
is an inseparable part of the
cycle of life and new birth.
The woman herself creates a
harsher effect in monochrome,
while the halo of soft colours
that surrounded her original
image has become dark
and heavy.

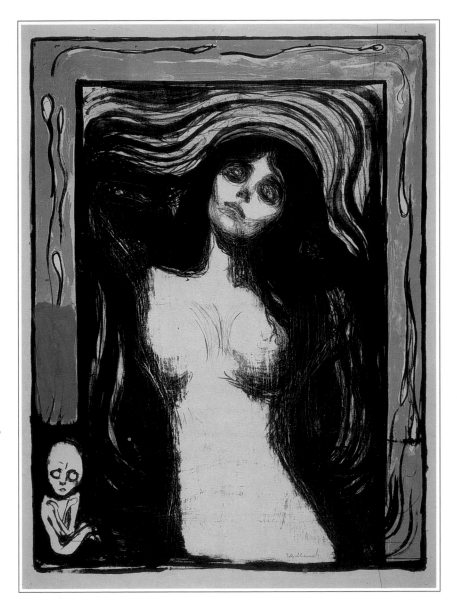

▷ **Self-portrait with Cigarette**  1895
© DACS 1996

FOLLOWING THE IMPACT of his 1892 Berlin exhibition, Munch adopted Berlin as a second home. Here he became one of the Bohemian circle – painters, sculptors, playwrights and poets – who gathered at the Black Pig bar. He was deeply affected by Berlin Symbolism and Expressionism, which inspired his work. But, as this painting makes clear, he also took the opportunity to familiarize himself with much older German traditions. This atmospheric self-portrait reflects a portrait tradition dating back to Dürer. Munch poses against a dense, dark background, where smoke from his cigarette mingles with the shadows. An almost theatrical illumination from the bottom right underlights his face and hand, emerging from smoky shade like the Demon King of pantomime. It is a painting of great intensity, not the least because stance and expression are characteristically ambiguous: it is hard to say whether that blank yet watchful stare means he has been caught off-guard for a moment, or is challenging us with his guard up

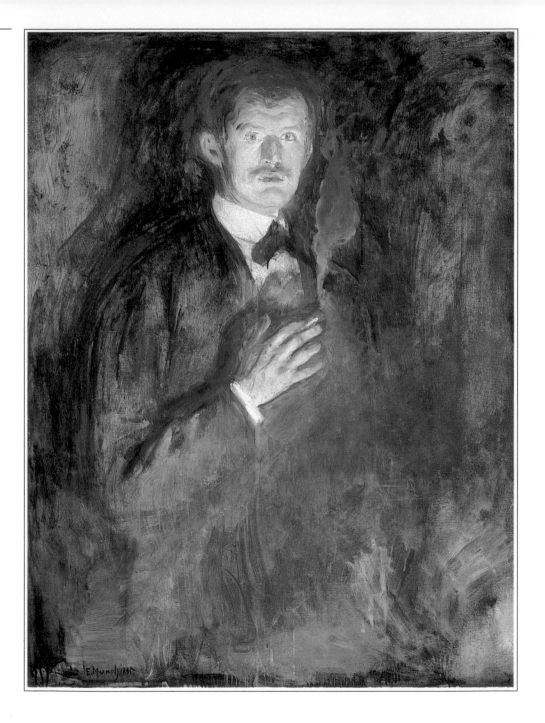

▷ **Vampire** (1895-1902)
©.DACS 1996

Woodcut  38.7 x 55.9cm

ONE OF THE MOST OVERT
expressions of Munch's fear
of female sexuality, this
disturbing image depicts
woman as succubus, draining
man's soul, and man as passive
victim. Its original title was
*Love and Pain,* to Munch
almost synonymous. Munch's
friend Adolf Paul has left an
account of its genesis in 1893.
He arrived at the artist's
furnished room in Berlin to
find him with  a new model,
'a girl with fiery red locks
streaming about her like
flowing blood'. He was
promptly press-ganged into
posing with her. '"Kneel down
in front of her and put your
head in her lap," [Munch]
called to me. She bent over and
pressed her lips against the
back of my neck, her red hair
falling about me. Munch painted
on, and in a short time he had
finished his picture *The Vampire.*'
In fact, 'finished' was hardly
the word, for Munch, as usual,
went on to rework the theme
in a series of prints. The earliest
was a single-colour lithograph;
he persisted with different
colour combinations, finally
combining lithograph and
woodcut in this 1902 version.

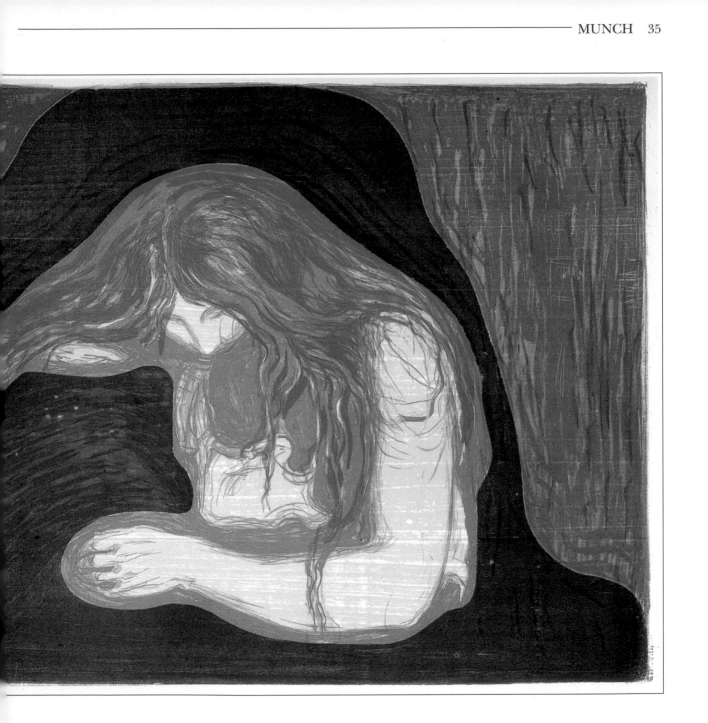

▷ **Jealousy** 1895
© DACS 1996

Oil on canvas  67 x 100cm

IN THIS LOVE TRIANGLE, two faceless figures act out the Fall of Adam and Eve under an apple tree. The female figure is blatant in her sin, her robe (whose brilliant colour identifies her as a 'scarlet woman') open to flaunt her nudity. Her male accomplice is so featureless, so generalized in face and clothing, as to be Everyman. In contrast, the face of the third figure is that of a real person. He faces away from the lovers, but his haunted face expresses his awareness of them. Though the title and the stylized figures make this a global study of emotion, it was inspired by a local situation. Berlin's Black Pig Bohemian circle had its own real-life *femme fatale* in Dagny Juell, nicknamed Ducha, the Norwegian wife of Polish writer Stanislaw Przybyszewski. Many of the circle, including Munch himself, were in love with her, though her husband is said to have borne her probable infidelities philosophically rather than suffering the torment Munch here ascribes to him.

*Courtesy of Rasmus Mayers Samlinger, Bergen*
*Photo: Geir S. Johannessen*

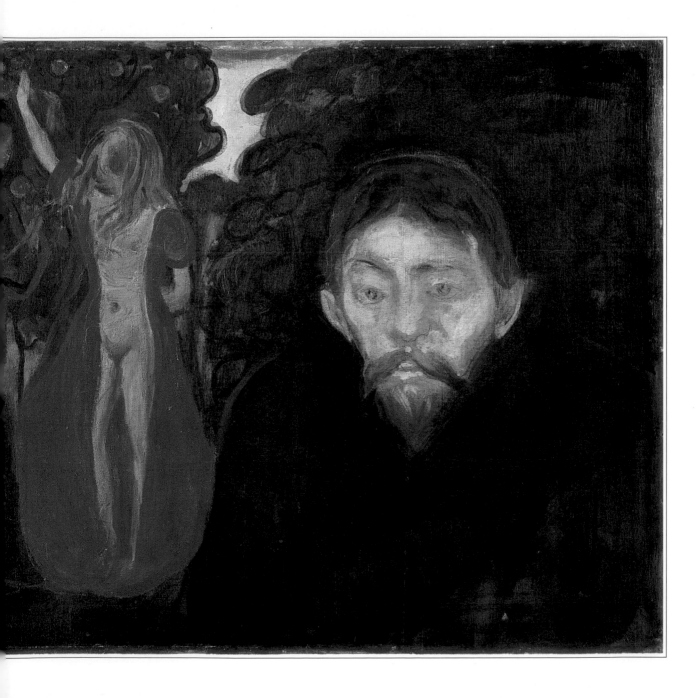

▷ **Puberty** 1894-5
© DACS 1996

Oil on canvas 151.5 x 110cm

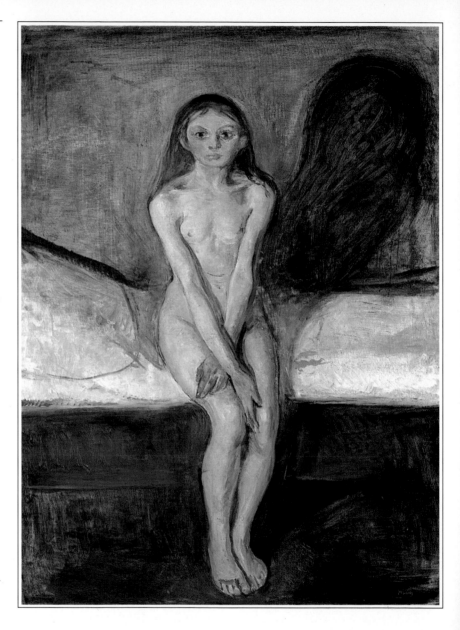

MUNCH DEPICTS a young girl
poised on the threshold of
womanhood. The painting
shocked his contemporaries,
yet rarely can so intense a
study have been made of a
naked girl-child without
tipping over into pornography.
In the fragility of her body
Munch portrays the ephemeral
quality of her condition.
She is balanced in the limbo
between innocence and
experience delicately and
fleetingly as a bird perched
on a branch; and with the
same fine poise, his portrayal
walks a tightrope between
compassion and objectivity.
Her broad face with its
pointed ears has a fey,
almost elfin quality; her body
is wholly human, with the
barely budding breasts and
scrawny arms contradicted by
the rich curve of her haunch.
Again, Adolf Paul has left a
record of the model who
inspired this study: 'She did
not look like a saint, yet there
was something innocent, coy
and shy in her manner – it
was just those qualities which
had prompted Munch to
paint her.' Yet though the style
is realistic, this is a masterpiece
of symbolism, going beyond the
portrait of an individual girl to
represent an abstract truth
about the human condition.

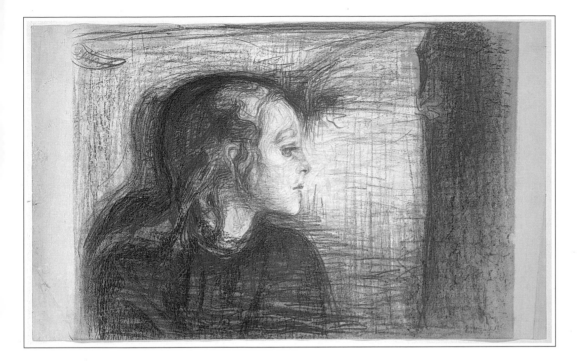

△ **The Sick Child**  1896   © DACS 1996

THE GIRL PORTRAYED here is poised on a very different yet equally universal threshold, that between life and death. It was in 1886 that Munch painted the first version of *The Sick Child*, which has been hailed as his first masterpiece and which he himself regarded as 'a breakthrough in my art'. Haunted by the memory of his young sister Sophie's deathbed, he strove to capture it on canvas, initially as a genre scene including the child's aunt grieving at her bedside. When it was exhibited, he recorded, 'No painting had aroused as much anger in Norway as this one.' Contemporary critics responded with laughter or horror, and found it 'completely lacking any emotional content'. But Munch, convinced of the rightness of his vision, became obsessed with capturing the image exactly as he saw it, reducing his subject to the girl's head alone. Painting at least six versions as well as numerous renderings in drypoint, chalk and lithograph, he pared his subject down to its essentials: 'the transparently pale skin, the trembling mouth, the shaking hands'. The death of an individual now symbolizes the pain inherent in the human condition.

▷ **The Lonely One** 1896
© DACS 1996

Etching 28.2 x 21.7cm

THIS ELEGAIC STUDY, also known as *Young Girl on the Shore*, has much in common with *Inger on the Beach* (page 13). Clear evening light bathes a tightly cropped area of sea, where a girl epitomizing Munch's image of virginal innocence gazes out. Her pose is used by Munch to express calm, as in his *Portrait of Inger* (page 22): her hands are folded serenely before her, and the long dress hides her feet to give the bell-shaped base of a statue. Here, though, she is seen from behind. Everything extraneous to the central image has been cut out – the horizon, the shore, even the girl's appearance, for the back view offers us no more than her dress and hair. Yet the scene is far from claustrophobic, for the whole painting is pervaded by light. The delicate play of light on the sea opens the picture up by creating a sense of distance and of the reflected sky. The foreground is ambiguous: is she standing in shallow water, or on wet sand that catches the light like water? This uncertainty flows on into the darkness in the middle ground – a line of rocks, or only a shadow? – that blocks the girl's way to the open sea of adult experience.

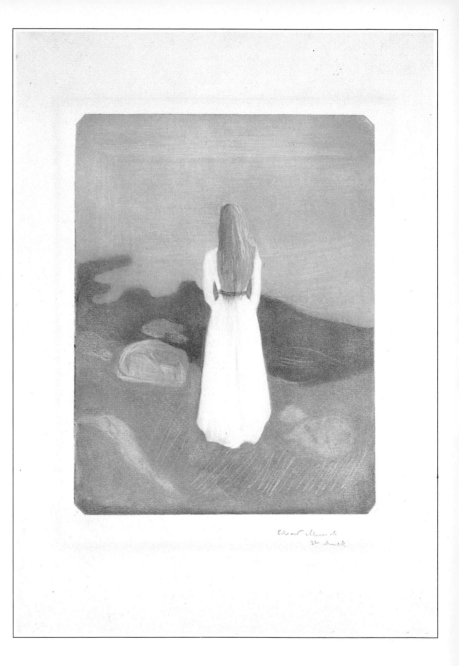

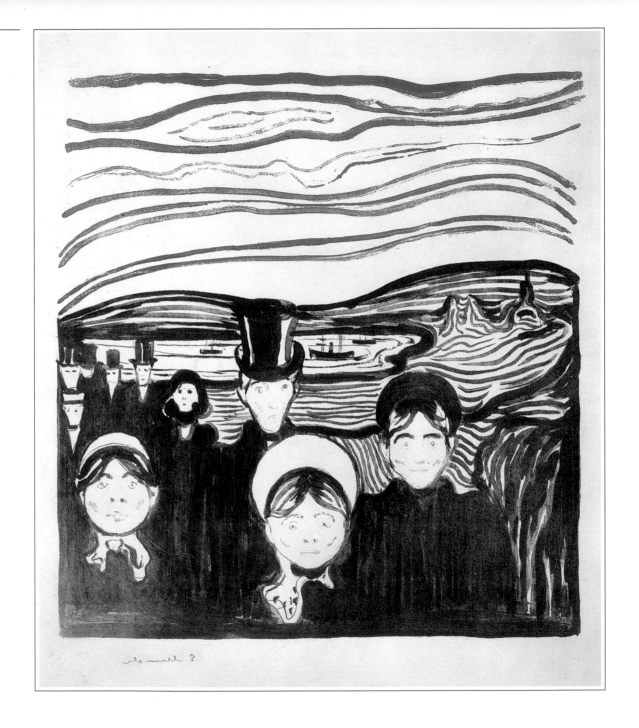

**Anxiety** 1896
© DACS 1996

Colour lithograph 42 x 38.7cm

◁ *Previous page 41*

MUNCH RETURNED over and over to favourite images. Here we have another version of the setting and the bloodstained sunset he used in *The Scream*, while the blank-faced crowd is clearly of the same line of descent as that in *Spring Evening in Karl Johann Street* (page 20). Lithography lends itself well to the stark, stylized symbols of Munch's neurotic fears. Here, the curves of the landscape are reduced to bleak blackness, those of the sky to sinister red slashes like wounds. Heavy outlines remove any any lingering Art Nouveau airiness and delicacy from these curves: they are powerful, sinewy and threatening. The faces of the crowd are doll-like masks: they have lost all their humanity under the pressure to conform. They stand waiting, mutely weighed down by the pressures of life that are echoed by the pressures of the heavy sky and landscape.

▷ **Mother and Daughter** 1897
© DACS 1996

Oil on canvas 135 x 163cm

THE TWO WOMEN POSE together, yet not together, on a hillside. Although they are side by side, the older woman's skirts overlapping the younger's, the flat, outlined style in which they are painted isolates them from each other. They are further separated by body posture. The young woman stands stiffly facing forwards, while the older woman turns her head, averting her eyes from her companion. They ignore each other, as if an argument has ended in sterile silence. Their rigid postures are imposed upon the hard curves of an oppressive, dark landscape. It is notable that they are costumed as the white-robed virgin and the old woman in widow's weeds of *The Women* (page 26): perhaps Munch is suggesting there can be no communication between these polar opposites. Typically, however, he refuses to explain, and leaves us to meditate on the matter ourselves. The two figures have been identified as the two positive female influences in Munch's life: his sister Inger, who gave him so much stability, and their aunt Karen Bjolstad, who cared for the family after their mother's death.

▷ **Melancholy. Laura**  1899
© DACS 1996

Oil on canvas  110 x 126cm

THE SUBJECT HERE is Munch's younger sister Laura, who suffered from mental illness and spent much of her life in an institution. In this heated, claustrophic scene Munch portrays not only Laura's tragedy but his own dread of the madness he feared he might have inherited. In view of his father's religious mania, as well as Laura's condition, he regarded his own sanity as tainted by heredity (and indeed, his own nervous breakdown arrived within a decade of painting this picture). This is no conventional portrait of mental illness. Instead of the gloomy shades we might associate with melancholy, Laura is framed by heated reds and oranges that communicate a violent sense of claustrophobia. The only overt darkness comes from Laura herself. She sits lumpishly, with hunched, heavy shoulders, weighted down by the leaden colours of her clothes. Munch is clear that her melancholy is no mere absence of hope, but an active and malevolent force. Though her prison has a window, it is no opening on to a world of light and freedom: its heavy frame forms bars, and the vista beyond is flat and grey.

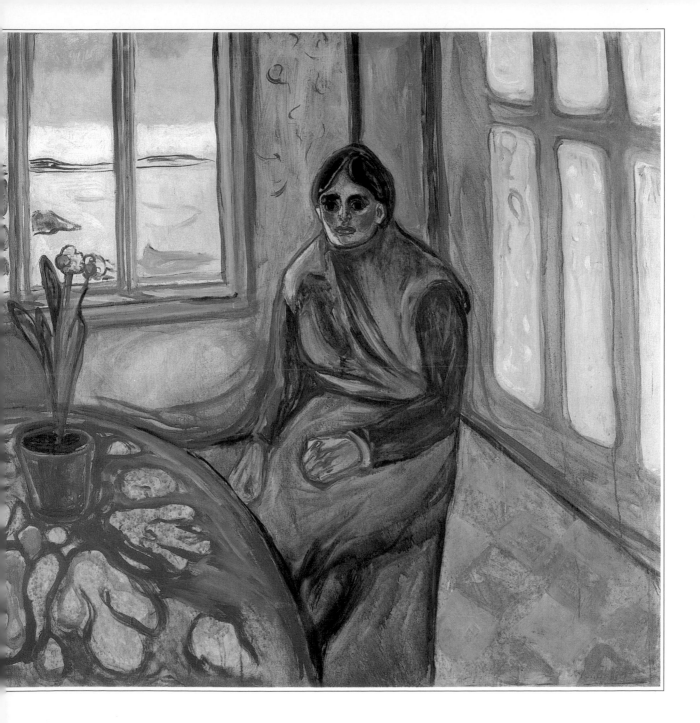

▷ **Winter Night** *c.*1900

Oil on canvas  80 x 120cm

FOR ALL THE TIME he spent in Germany, France, Belgium and Italy, Munch never lost his love for the beauties of his native Norway's coastal scenery. He returned again and again like a homing bird to Åsgårdstrand and neighbouring fjords; again and again he painted Norwegian landscapes. Here he was concerned to capture not what he saw with his eyes, but the emotional impact this had upon him. He explained, 'I do not finish a work until I am a bit removed from the vision of it so that my memory can clarify its emotional impressions. Nature confuses me when I have it directly in front of me.' This winter scene, painted in a simplified Art Nouveau style, was inspired by his stay at Ljan, south of Oslo. It is a study in contrasts: dark trees against white snow, the rounded shapes of the foreground trees and the smooth curves of the fjord against the jagged pines that cut across the middle ground like a row of teeth. Bright winter daylight emphasizes brightness and shadows and lends a cold brilliance to sea and sky. No human presence intrudes upon the scene: this is between Munch and the world of nature alone.

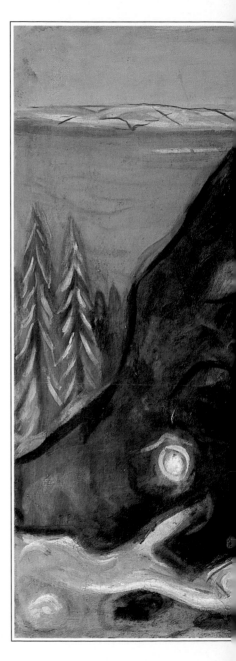

▷ **The Dance of Life**  1899-1900
© DACS 1996

Oil on canvas  125 x 191cm

IN THIS ELABORATION of *The Women*, Munch deploys a symbolism both more overt and more traditional than usual. The 'dance of life' is the dance of death of medieval iconography. Munch's original plan was to show 'a young minister dancing with a woman with flowing hair' among 'a wild crowd of people… fat men biting women in the neck – caricatures of strong men embracing the women.' His painting developed its own impetus, and the dominant image is that of the three key women. On the left, the white-clad virgin, still unpartnered, steps forward to join the dance, her arms shyly half-open. Next, the temptress reels in her catch. Her red dress has begun to engulf the man who will drown in her sensuality. The older woman in black stands back, no longer a participant but a bleak spectator. All three wear the same face, said to be that of Tulla Larsen, with whom Munch had a passionate, self-destructive affair 1898-1902. Among the dancers, a man in black with a leering, mask-like face  swarms lustfully over a white-clad girl who pulls desperately  away. This is Death himself dancing with the maiden, confirming the only possible end to the dance of life.

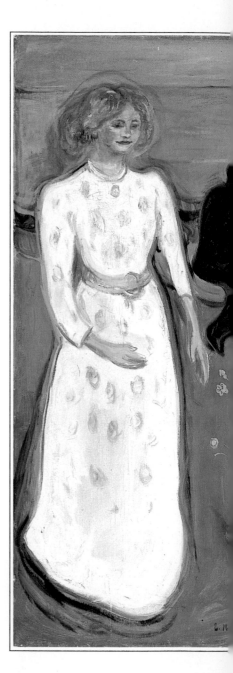

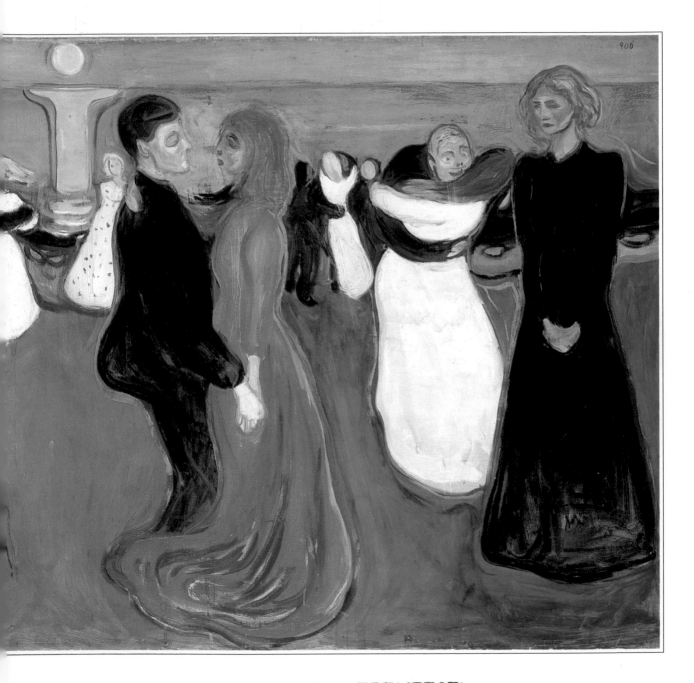

▷ **A White night** 1901
© DACS 1996

Oil on canvas 115.5 x 11cm

A YEAR LATER, Munch translated his vision of Winter Night (page 46) into what has become the most famous of his Norwegian landscapes. Many of the shapes have barely changed, but the reworking has intensified the emotional content. Significantly, daylight has become moonlight, the contrast between light and dark subtler. The clear sky of the earlier version has acquired a magical frosty quality, the far shore almost disappearing into a luminous haze, while the sea is frozen into rhythmical swirls of ice. The gaps in the foliage of the foreground trees, through which we glimpse spots of snow (present in *Winter Night*) have become stylized into shapes suggesting eyes: the trees have become spectators, drinking in the beauty of the northern night. Human figures remain absent from the scene but Munch

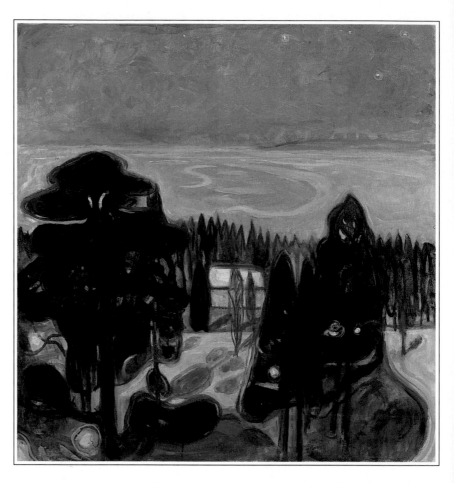

has introduced a small windowless house among the trees. The blind house and the watchful trees form a gentle rebuke to his fellow mortals for failing to use their eyes, to make the 'time to stand and stare'.

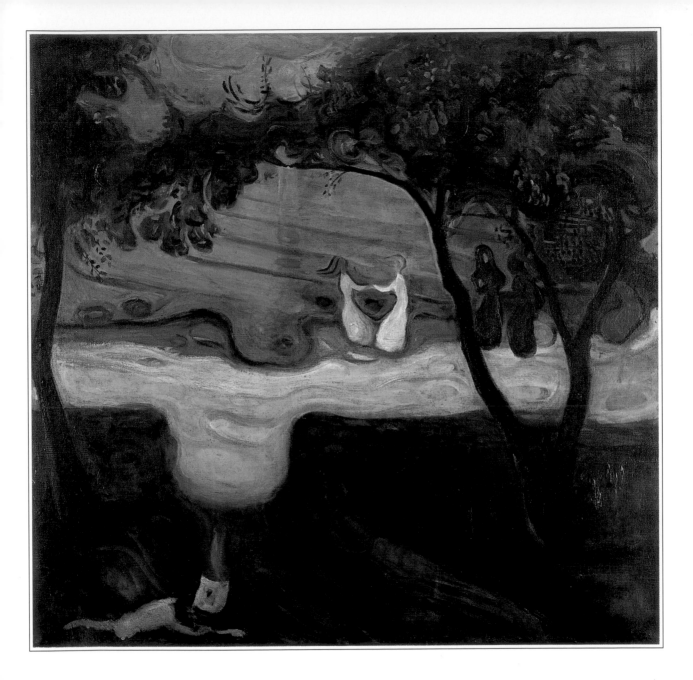

▷ **Melancholy** 1901
© DACS 1996

Coloured woodcut

MUNCH PAINTED THIS SUBJECT, also known as *Evening, Jealousy, On the Beach* and *The Yellow Boat,* in 1891-3, and later reworked it repeatedly in different media. A man sits, lost in melancholy thought, on the beach, while in the distance a couple are about to embark on a boat. Clearly the man's loneliness is linked to, and presumably caused by, the existence of the other two figures as a couple and their departure together. Munch has returned to a theme he used in *Jealousy,* and one which he felt strongly: the pain of the third member of a love triangle. Supposedly, this painting was again inspired by a real-life love affair among Munch's circle of friends. The foreground figure has been identified with Jappe Nilssen, a young journalist, and the couple with the painter Christian Krohg and his wife Oda, the object of Nilssen's jealous love. But Munch himself was all too familiar with the loneliness of unhappy love, and displays a great deal of empathy, if not identification, with this role.

**The Dance on the Shore** 1900-02
© DACS 1996

Oil on canvas  99 x 96cm

◁ *Previous page 51*

AFTER THE PORTENTOUS symbolism of *The Dance of Life,* we encounter two girls engaged in a quite different dance. Clear light colours and rhythmical open curves create an impression of airiness, freedom, even happiness. The tree that partially frames the scene is much more elegant and decorative than Munch's usual trees. Its branches break out into ornamental swirls , and it is bedecked with delicate, frivolous long sprays of flowers. Five women appear on the shore. The two that take the eye are the dancers, in white and clear yellow, whirling round with their bright hair flying – a pair of Munch's iconographic virgins enjoying their innocence. Next, a pair of bowed figures in black seem to be their counterparts, the older women who only observe the dance, framed or confined as they are by dark branches. Or are they, as their posture suggests, themselves engaged in a more restrained dance of their own? At any rate, the one who is sitting out this dance is the temptress in red. She has her place in life, but here she and her disruptive influence are barred from the dance.

▷ **Girls on the Pier** *c.*1901
© DACS 1996

Oil on canvas  136 x 125cm

THIS TRANQUIL SCENE evidentl
meant a great deal to Munch
for between 1899 and 1930
he painted no less than sixteen
versions. On the bridge at his
beloved Åsgårdstrand, three
girls lean on the railing, gazing
down into the water. Beyond
them a white house nestles
within its low wall, dwarfed by a
massive tree. The steep diagonals
of the bridge recall those of
*The Scream,* but are far less
exaggerated, drawing us gently
into the landscape. The natural,
easy pose of the figures, the
harmonious colours, and the
soft swirls of the landscape
create a contemplative beauty.
For Munch, however, life – and
art – are rarely that simple.
The water may symbolize the
distorting powers of human
thought or memory upon reality.
The girls, heedless of their
surroundings, gaze down
into water where the world is
reflected in darker shades and
subtly changed. In reflection, the
tree loses its vibrant colours

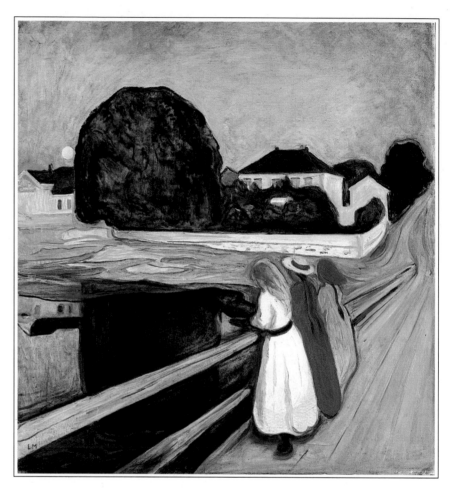

and gentle curves to become a
great dark mass, a barrier that
blocks out the view, while the
reflected house has lost a
chimney and gained a window.

**▷ The Family** 1900
© DACS 1996

Oil on canvas 197 x 122cm

MUNCH TURNED TO a traditional
allegory when he painted this
little group setting out on their
journey along the road of life.
The road winds from past to
future, its end out of sight
and unknowable. The family
comprises three generations,
dressed alike in black. The
child leads, tugging slightly
ahead, for the future is hers.
The doll she clutches symbolizes
the next generation which she
has in her gift. Though this
promises fertility and the
continuation of the human race,
she wears the same funereal
black as the older women. It
reminds us that, for the
individual, the road of life
always ends in death. The
statuesque mother controls her
daughter's progress with a hand
that seems more firm than
affectionate. She is still young,
still attractive, but maternal
responsibility bars her from
the white robe of innocence,
or the scarlet in which Munch
clothes his gay, destructive
temptresses. Behind them, the
grandmother turns away from
the road: what lies ahead is no
longer her real concern.

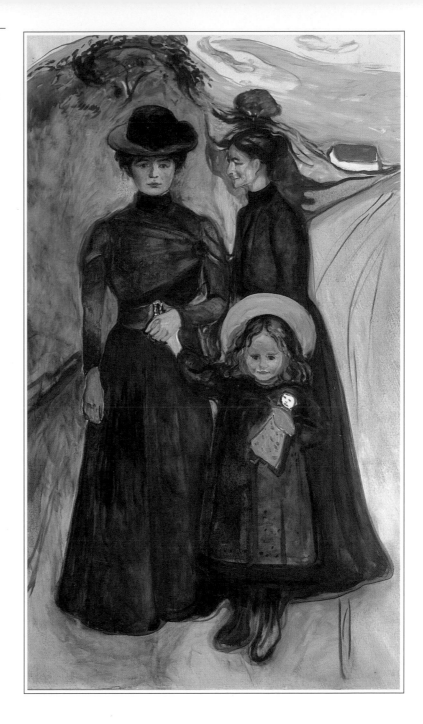

▷ **The Four Sons of Dr Max Linde** 1903
© DACS 1996

Oil on canvas

IN THIS CHARMING yet unsentimental group portrait, Munch has captured a delightful spontaneity. Informally posed, the four boys have clearly been summoned from play and endure this interruption to their own pursuits, awaiting permission to return. Differing stances and expressions reflect a shared impatience but also indicate characters differences. The eldest leans against the door looking bored, while the two little ones seem slightly nervous and the boy on the right, legs spread, hand on hip, displays confidence and the hint of a habitual swagger. The boys' father, Dr Max Linde, a wealthy eye specialist and art collector, was a patron and friend of Munch's from the 1890s and commissioned a number of paintings, engravings and lithographs of his family and home. Munch also produced 11 paintings meant to form a nursery frieze. Linde rejected these, considering some of the subjects (like *Loving Couple in the Park*) unsuitable for children. It was a happier choice when he commissioned his sons' portrait as a birthday gift for their mother.

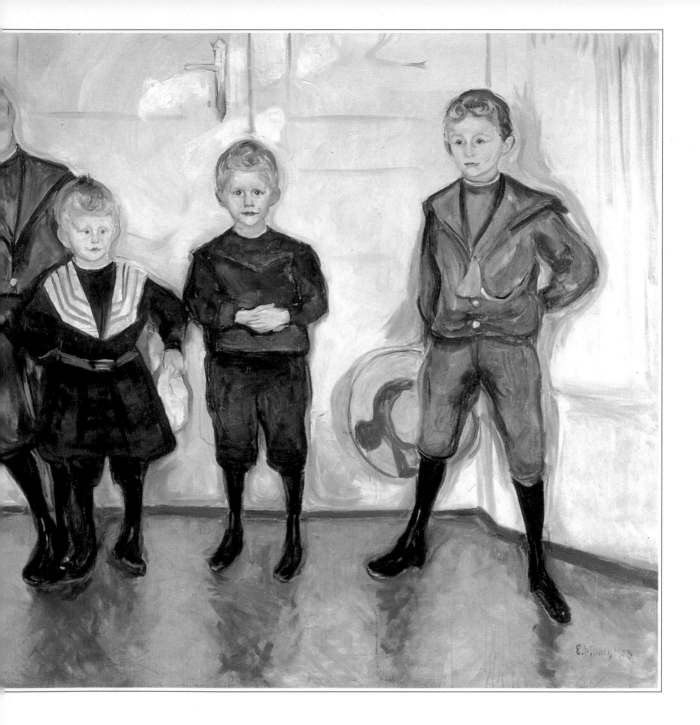

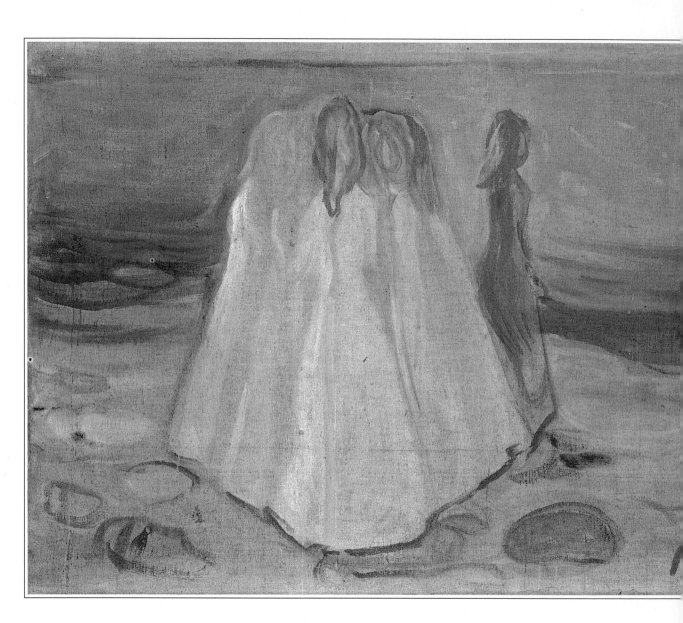

◁ **Girls on the Shore**  1906-7
© DACS 1996

Oil on canvas

IN A DELIBERATELY roughly painted scene, Munch returns to a favourite motif from his lexicon of female archetypes: the awakening of sexual desire. A group of white-clad girls clusters together on the shore, pressed so tightly together that they form a single unit. It is impossible to tell how many girls there are; their white dresses meld together into a bell-shaped mass. Heads close together, they are turned inward upon themselves, unconscious of the world beyond. Their unawakened senses do not respond to the beauties of the sea and the shore. But the brilliantly blue sea is full of dancing light, and on it sails a little pleasure boat, its passengers gay in red and white and yellow. And one girl has broken away from the introverted little group to answer the call of light and life. Though she is only a step or two away from the others, the significance of her movement is clear from the colour of her dress. Its hem still forms part of the white group, but colour flowing strongly upward into it clothes her in the red associated in Munch's lexicon with the sensual woman. She is poised on the brink between girlhood and womanhood.

▷ **Young Girl in a Red Hat**
*c.*1905 © DACS 1996

Oil on wood  58 x 46.5cm

IMAGES OF CHILDHOOD
fascinated Munch during the
early 1900s, when he painted
such studies as *Four Girls at
Åsgårdstrand.* The subject of
this head-and-shoulders
portrait seems to be the same
model who appears in *The
Family* (page 55), with her mass
of dark hair, big dark eyes
and serious little face. She
wears a festive red hat, and
matching red checked dress
or coat. Her expression is
unrevealing, even secretive,
but Munch's palette is rather
more explicit. For Munch,
colour was never a matter of
simple representation of
surface appearance. Rather,
it was a language in which
he could express emotional
realities.  Here he has used the
hot,  feverish, colours usually
associated in his works with
stress, claustrophobia, and
fear. This renders the girl's
seriousness faintly sinister,
suggesting that the liveliness
natural to her age may have
been driven out by fear or
suffering – and reminding us
that Munch's own childhood
memories ('illness, madness

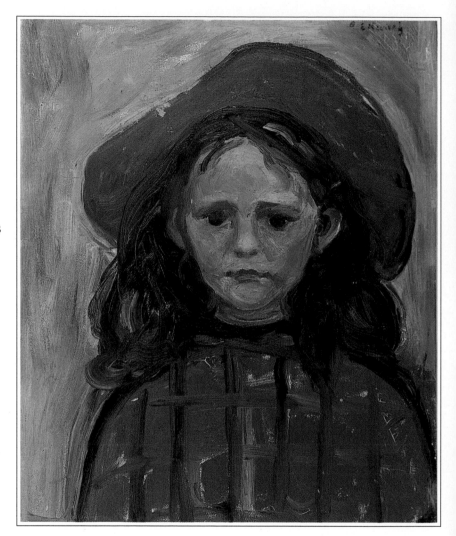

and death') were anything
but happy. This study belongs
with *Melancholy* (page 44)
and *Anxiety* (page 42) rather
than the study of privileged
childhood that presented
itself in *The Four Sons of
Dr Max Linde* (page 56).

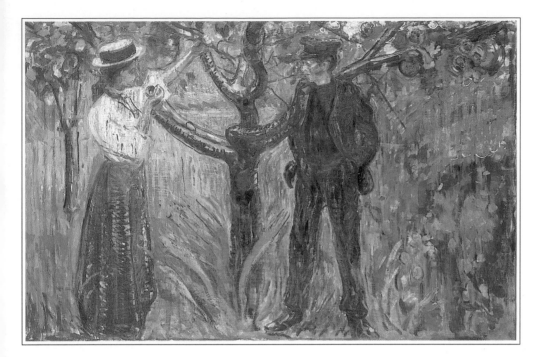

△ **Adam and Eve under the Apple Tree**  1904  © DACS 1996

Oil on canvas

DESPITE THE PAINTING'S TITLE, it is a  young couple in modern dress who stand under the tree. The woman rests one hand casually upon a branch, and with the other raises an apple to her mouth. She is neatly dressed in white blouse, skirt of tell-tale red and jaunty summer straw hat, and with her easy stance looks well in control of the situation. The man gazing at her seems less assured. In his sombre working-class clothes, he is clearly out of his natural habitat in this Eden of an orchard. He does not face the woman directly but twists his body away, hands tucked defensively into his pockets. The tree itself forms a barrier between them that neither seems likely to cross. The soft, sinuous winding of its branches mimics the curves of the serpent which is implicit in the setting. The tree is a frequent symbol in Munch's paintings – bearing fruit, sheltering life, nourished by the dead buried under its roots, or recalling that tree from which Eve plucked man's destruction. For Munch, the scene in Eden epitomized the relationship between the sexes, Eve the eternal temptress, Adam the man condemned to suffer by her actions.

▷ **Girls on the Jetty** 1905
© DACS 1996

Oil on canvas

IN YET ANOTHER of the many versions of *Girls on the Bridge*, Munch has cropped his original picture dramatically, bringing the girls into greater prominence and cutting down the background. The sky is gone; all that remains of the houses is the white encircling wall; the limited reflections in the water are darker and more threatening. The bridge no longer flows on to the road, but ends abruptly. The most dramatic change, however, is that the nearest girl has turned round. Turning her back on the water and on her companions, she stares blankly ahead with a suggestion of fear in her expression. No longer are the three united in a serene innocence, and the split is underlined by a new emphasis on the colour of the centre girl's costume. Her red dress glows as fiercely as fire; she has exchanged the straw hat of the earlier painting for a close-fitting cap of the same fiery red. It seems she has crossed the bridge between innocence and knowledge, while the white-clad virgin has yet to make the crossing.

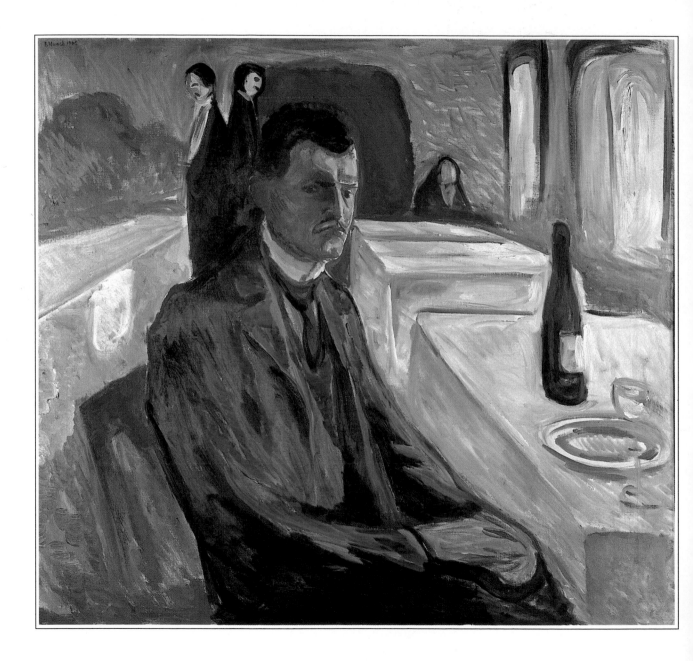

◁ **Self-portrait with Bottle of Wine**  1906
© DACS 1996

Oil on canvas  110.5 x 120.5cm

WITH GROWING INTROSPECTION, Munch painted an increasing number of self-portraits. Typically, these are studies less of the man than of his moods – usually unhappy. Here he depicts loneliness in a Weimar restaurant. At this time a nomadic lifestyle and a growing drink problem were taking their toll on him. He was living in a series of boarding-houses, driven out on to the street from time to time by lack of money. The restaurant with its clean white tablecloths and black-suited waiters must have seemed an inimical environment to a man who often could not afford food, and sometimes not even a roof over his head. It is almost empty, offering no company. The only other diner, a faceless woman in black, lurks at the furthest seat, while two caricatured waiters stand forbiddingly at the rear, joined back to back like Siamese twins. Munch twists away from them to turn a face of intense despair upon the viewer. Notably, this eating-house does not even offer the solace of food: the lone woman has nothing before her, Munch only an empty plate and the false comfort of his bottle and glass.

**Self-portrait at the Clinic** 1909
© DACS 1996

▷ *Overleaf page 66*

THE COMBINATION of unhappiness, isolation, overwork and alcoholism culminated, in 1908, in a nervous breakdown. Suffering from hallucinations, and in dread of insanity, Munch was persuaded to enter a psychiatric clinic in Copenhagen. Here Dr Daniel Jacobson supervised eight months of treatment, from which the painter emerged 'cured'. There would be no more excessive drinking, no more rootless wandering across Europe (he settled now in southern Norway) – and no more tortured symbolism in his art. From now on the emphasis in his paintings was to be on what he saw, rather than what he felt. In this 1909 study the convalescent artist looks at himself with a new detachment and self-knowledge. It is the portrait of a survivor, a man who has come through the years of emotional turmoil, weary but no longer tormented. Years before Munch declared, 'I would not cast off my illness, for there is much in my art that I owe to it'. Now, having accepted the cure, he would never suffer, or paint, as intensely again, but a new vitality in the free brushstrokes and bright, dancing colours, proclaims acceptance of his new life.

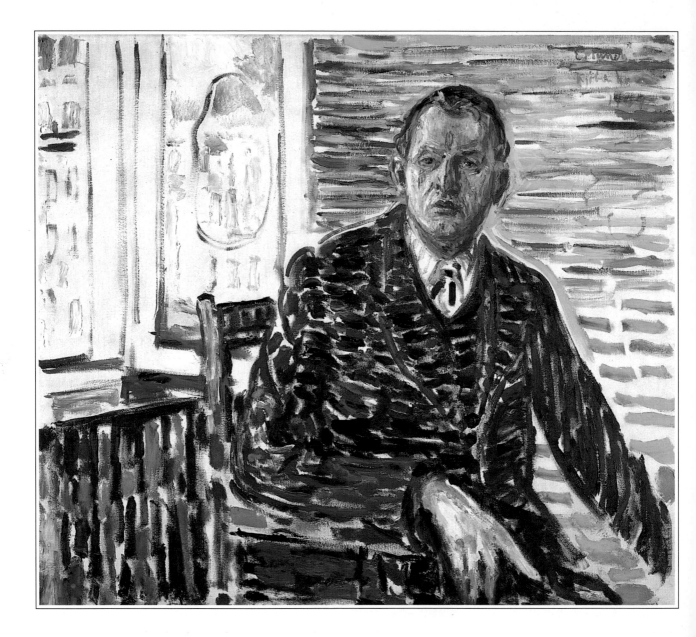

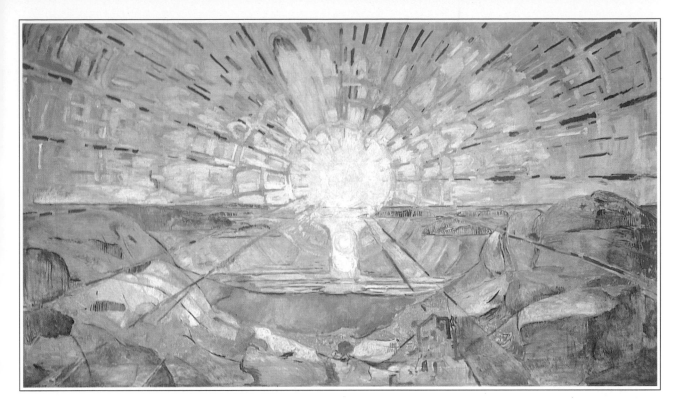

△ **The Sun**  1909-16  © DACS 1996

Oil on canvas

IN 1911 MUNCH won a competition to paint a series of murals for the Great Hall of Oslo University. Although he began work straight away, there were several years of argument before the University finally accepted his designs. His scheme comprises three large canvasses and eight smaller, forming an allegory of 'the powerful forces of eternity'. Two of the major pictures depict human life. In *History*, an old man tells a boy stories of the past; in *Alma Mater*, a mother suckles her infant, while her other children watch. The central painting which these two flank was originally intended to feature 'a mountain of men', with a mass of human figures struggling upwards to the life-giving sun. In the end, however, Munch chose to portray an emblematic sun alone. In his earlier paintings, the sun over the sea, with its (often phallic) reflection, is a favourite motif. Here it dominates, and irradiates, the entire picture. The glowing shafts of light reach out over sea and land, extending their exultant warmth towards the viewer. The rocky landscape is that of Kragero, an island in Oslo Fjord, where Munch made his home on his return to Norway.

▷ **Life** 1910

Oil on canvas

THIS ALLEGORICAL PAINTING
belongs to a genre popular in
Scandinavia at this time, but
the composition is very much
Munch's own. The central
image of the tree under which
the figures are grouped recalls
earlier works such as *Adam and
Eve under the Apple Tree* (page
61) and *The Tree*. The troubled
division between the sexes is
also characteristic. The women
are light-coloured, fluid forms,
sheltered and protected by the
tree; while the men are sombre
figures, their shoulders bowed.
Their dark, working-class
clothing makes them precursors
of Munch's later studies of
working men. The spatial
relationship of the six figures
is oddly unintegrated and
unsatisfying, as if Munch is
uncertain about their place
in this peaceful, green setting.
There is an apparent lack of
confidence in his arrangement
of their limbs, which is
generally stiff and unnatural.
The impression is that Munch,
unusually, is groping for his
own meaning in this painting,
its message somehow lost in
the symbolism.

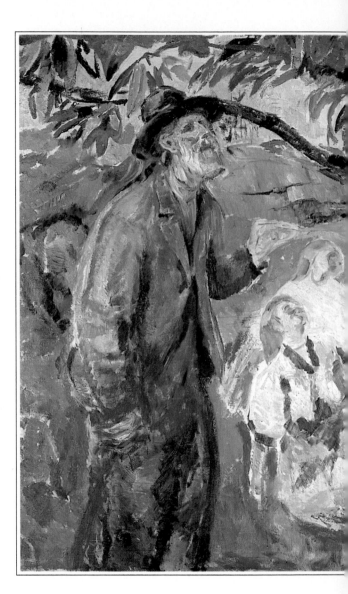

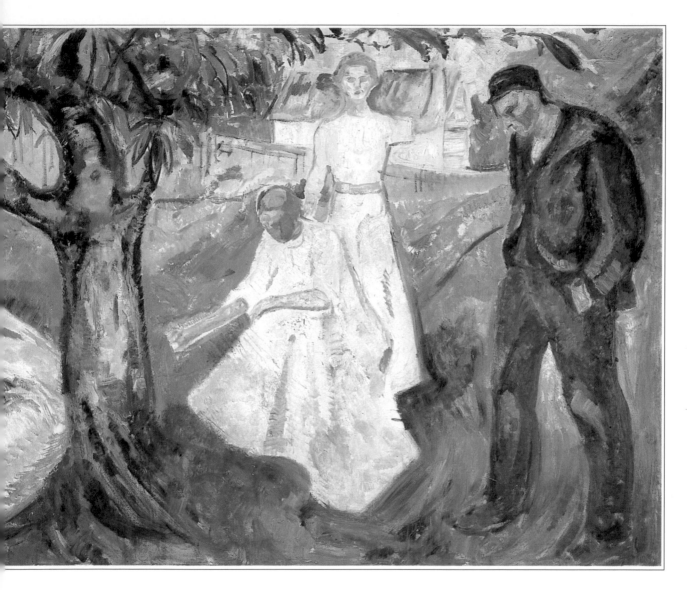

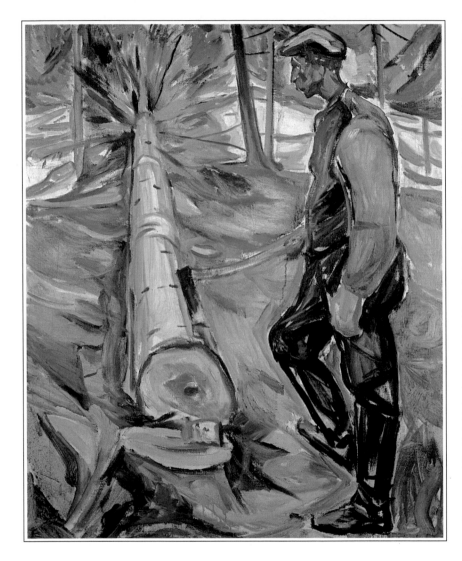

◁ **The Woodcutter** 1913
© DACS 1996

Oil on canvas

IN LATER LIFE, Munch painted numerous scenes of manual labour – ploughing, reaping, shovelling snow, and the like, as well as workmen on their way to or from work. Despite occasional exceptions such as *Washerwoman* (1920-30), female workers failed to capture his attention in the same way; and he also lacked interest in depicting working-class life beyond the scene of labour. In most cases, his theme is the power and rough dignity of toil, though he never makes the mistake of romanticizing this. Here, the focus is shared by the woodcutter and the tree he has just felled. Though one has destroyed the other, there is an equality between them, a sense of a fair match: human life is properly integrated with the natural environment. The man stands, considering his work, his legs awkwardly braced as if he had just straightened up from his task. At his feet, the section of cut wood glows like a sun, and our eyes are led up the tree trunk to where its toppled branches explode in a green and brown sunburst.

▷ **Man Digging** *c.*1915
© DACS 1996

Oil on canvas

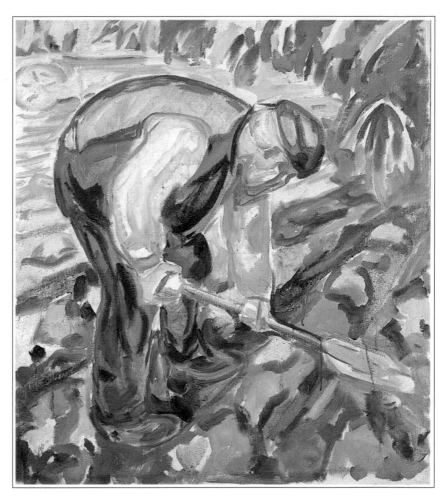

THE GRAVE DIGGER'S employment, the most evocative of all labour, carries with it centuries of literary and visual imagery. Yet Munch, who knew so well how and when to deploy symbolism in his paintings, has taken pains to avoid any overt symbolism. Here we have a simple man engaged in his task, stooped over his spade as prosaically as any farmhand turning the soil. Indeed, Munch has avoided any of the conventional imagery associated with the graveyard. There are no other graves in sight, no gaping hole at the worker's feet, only furrowed earth where plants grow in straight lines like cabbages. Indeed, without the painting's title, we might assume this bent old fellow is merely tending his garden. And here we have our clue. By bringing out the very ordinary nature of the gravedigger and his work, Munch strips death of its frightening trappings and sets it in its context as a natural part of life's cycle. As with his other studies of rural labourers, he depicts man in harmony with the natural world.

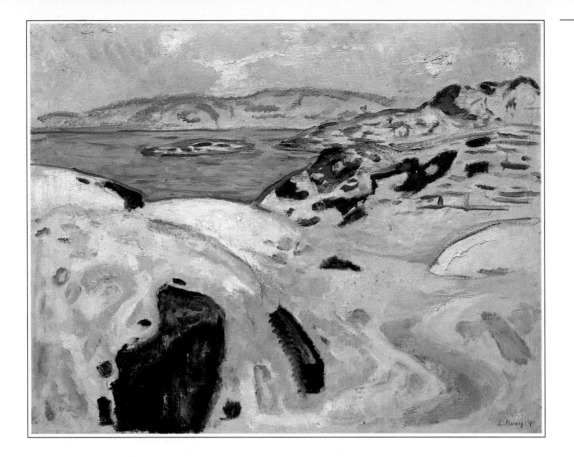

△ **Winter on the Fjord** 1915
© DACS 1996

Oil on canvas 103 x 128cm

SOMETIMES MUNCH PAINTED the coast as background to his main theme, sometimes as pure landscape, but always with sensitivity, even tenderness. In this evocative portrayal of Oslo Fjord, the tide dashes in a violent swirl of white foam over the foreground rocks. Yet it is a non-threatening violence, expressed in rounded, feminine curves and soft colours. The eye is led beyond the breakers to the uplifting serenity of calm sea, purple-hazed mountains and a shimmering sky. Limiting his palette and using bold, sure brushstrokes, Munch sets before us the eternal battle between waves and rocks, so equally matched that they achieve a natural equilibrium. Here we have not so much a celebration of coastal beauty as a meditation upon it, and upon the solace nature brings to troubled men.

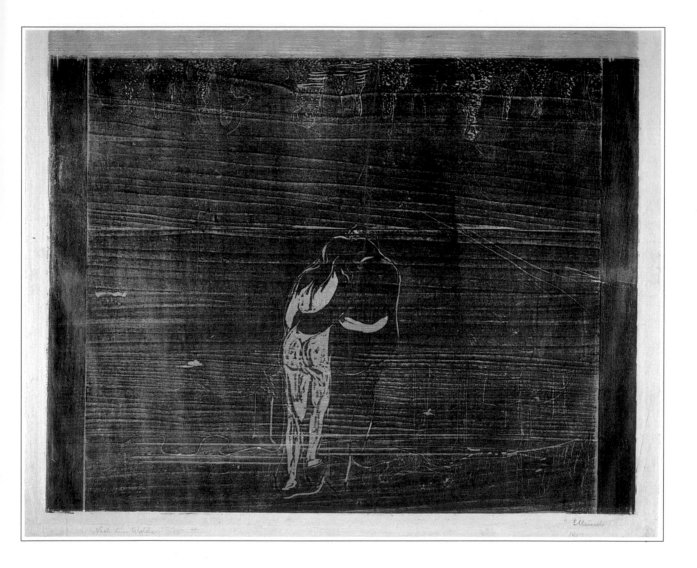

**Towards the Forest**  1897  © DACS 1996

Woodcut

◁ *Previous page 73*

TWO LOVERS, closely embraced, walk towards a pine forest. Since the girl wears virginal white, we may assume her lover is leading her into the dangerous forest of sexuality. She leans tenderly and timidly into his clasp. But her companion is depicted far less naturalistically. In fact, he is an amorphous black shape, oozing around her in a manner more sinister than loving. The subject here is not so much love as Munch's deep-seated fear of sexuality. Since producing his first woodcuts in 1896, Munch had developed innovations which transformed this technique. He moved away from the large, simple forms traditionally used, introducing a new delicacy and lyrical quality. He went on to make greater use of the structure of the wood itself, whether using its natural pattern or cutting the wood against the grain. The delicacy of touch and intimacy he achieved with works like *Lovers* were to influence a whole generation of artists, particularly in German Expressionism.

▷ **Haymaking**  *c.*1916  © DACS 1996

Oil on canvas

UNLIKE *The Woodcutter* (page 70) and *Man Digging* (page 71), this labourer dominates the land he works, a bold vertical figure against the field's soft horizontals. But the painting's composition and colour make it clear that he, like them, is in harmony with nature. The rounded shapes of the trees are echoed in the cloud formations; the curve of the horizon sweeps into the smooth flow of the path; and tall flowers spring from the grass with the same vertical line as the human figure. The haymaker's work, we see, is as much part of the season as the ripening grass itself. A few years later (1922), Munch would proceed from his studies of rural labourers to a set of twelve urban murals depicting factory workers. This small *Frieze of Life* was painted for the workers themselves, to adorn the canteen in the Freia Chocolate Factory in Oslo.

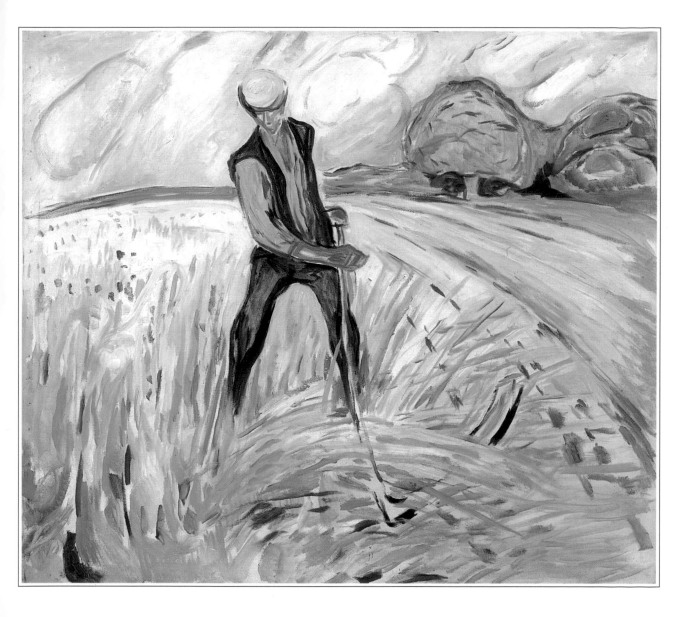

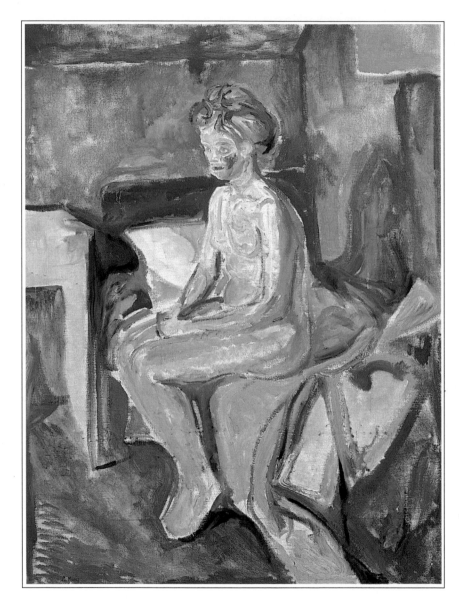

◁ **Girl Seated on the Edge of Her Bed** *c.*1917
© DACS 1996

Oil on canvas 141 x 105cm

THE SUBJECT IS THE SAME as that of *Puberty* (page 38), but no greater contrast could be imagined. Gone is the symbolism in favour of a purely pictorial approach. The painting is remarkable for its hot colours – burning reds, pinks and oranges. The blazing fireplace labours the point and even the girl herself is a heated pink, with a hectic red flush on her cheek echoing the red of the bedhead. She sits tensely upright, her bottom poised on the edge of the bed as if she has just plonked herself down. Unlike the dreaming girl in *Puberty*, her face has a look of sulky expectancy and her thoughts do not seem to be pleasant. Her expression and pose suggest a bored prostitute waiting for her client to join her on the bed, or for him to depart. Though her posture is not sexually inviting, the sultry, claustrophobic atmosphere and hot colours imply not merely sexual maturity but decadence – the jaded, fleshly descendant of the red-gowned temptress of earlier paintings.

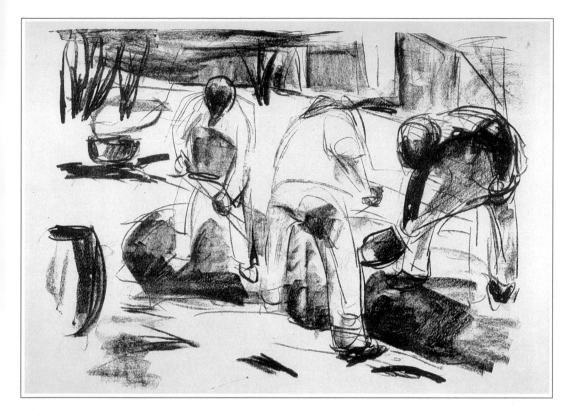

△ **Three Workmen** 1920 © DACS 1996

Lithograph with hand-colouring

MUNCH CREATED the stark black-and-white original of this lithograph as early as *c*1912. From 1920 onwards, work and workmen became his principal theme, and it was then that he produced this tinted version. The three workmen bend together over their shovels, whose diagonal lines draw the eye to the centre of the picture. They are wholly engaged in their task, apparently unaware of the artist. This contrasts with an earlier painting, *Workmen in the Snow* (1912), in which three workmen pause in their work to face the artist as if posing for a photograph. In 1936, Munch integrated this picture with three other studies of men at work into a huge composition intended to decorate the Council Chamber of Oslo Town Hall. However, recurrent trouble with his eyes prevented him from completing this mammoth undertaking.

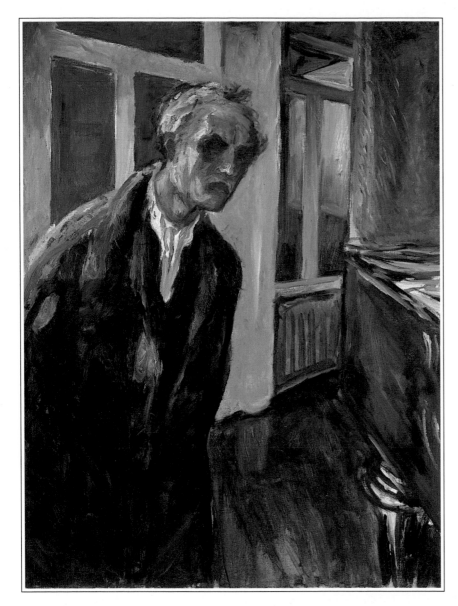

◁ **Self-portrait,
Wanderer by Night**  1923-24
ⓒ DACS 1996

Oil on canvas

DESPITE A RECURRENT eye
complaint which frequently
prevented him from working,
Munch's last years yielded a
number of paintings. These
include several troubling self-
portraits dwelling upon the
changes wrought upon him by
the advance of old age. A sense
of his own mortality pervades
works like *Cod Lunch* (1940), in
which the cod's head on his
plate becomes a *memento mori*,
or *Between the Clock and the Bed*
(1940-2), where the artist waits
between the clock, symbol of
passing time, and what must
soon become his deathbed.
*The Night Wanderer* was painted
at a time of particular stress.
The Nazis had condemned
Munch's works as 'degenerate'
and confiscated 82 of his paint-
ings from German museums;
now Germany was about to
invade Norway. Munch presents
himself as a haggard, ageing
man, roaming sleeplessly
through the house by night.
With his sunken eyes and
apologetic stoop, he haunts
his own home like the ghost
he must soon become.

## ACKNOWLEDGEMENTS

The publisher would like to thank the following for their kind permission to reproduce the paintings in this book.

The works of Munch © The Munch Museum/The Munch Ellingsen Group/DACS 1996

**Oslo Kommunes Kunstsamlinger, The Munch Museet, Oslo:** 9, 11, 12-13, 19, 20-21, 26-27, 31, 34-35, 39, 40, 43, 44-45, 53, 61, 64, 65, 71, 74, 75, 77, 78;  **Munch Museet, Oslo/Národni Galerie, Prague:** 52;  **Munch Museet, Oslo/Museum Behnhaus, Lübeck:** 56-57;  **Munch Museet, Oslo/Oslo City Hall:** 68-69;  **Munch Museet, Oslo/Newcastle Polytechnic Gallery:** 70; **Nasjonalgalleriet, Oslo/Kunsthaus, Zurich:** 16-17, 46-47; **Nasjonalgalleriet, Oslo** (Photos: J. Lathion): 15, 18, 22, 23 (*The Scream*, also used on front cover), 28-29, 30, 32, 38, 43, 48-49, 50, 54, 72;  **The Museum of Modern Art, New York** – The gift of Mr. and Mrs. H. Irgens Larsen and acquired through the Lillie P. Bliss and Abby Rockefeller Funds. Photograph © 1995 The Museum of Modern art, New York: 24-25;  **Rasmus Mayers Samlinger, Bergen** (Photo: Geir S. Johannessen): 36-37;  **Thielska Galleriet, Stockholm:** 55;  **Kunsthalle, Hamburg** (Photo: Elke Walford, Fotowerkstatte): 58-59, 62-63;  **Von der Heydt-Museum, Wuppertal:** 60;  **Oslo University Hall, Oslo** (Photo: O. Væring): 67;  **Nationalmuseum SKM, Stockholm:** 76

Every effort has been made to attribute the copyright holders correctly and we apologise in advance for any unintentional error. We would be pleased to insert the appropriate acknowledgement in any subsequent edition of this publication should the occasion arise.